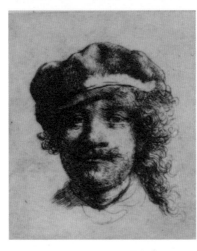

"They came for the Rembrandts..."

ISABELLA
SEWART GARDNER
MUSEUM

STOLEN

The Gardner Theft

❦ BENNA BOOKS | A Boutique Press for Artists & Writers | An imprint of Applewood Books | Carlisle, Massachusetts

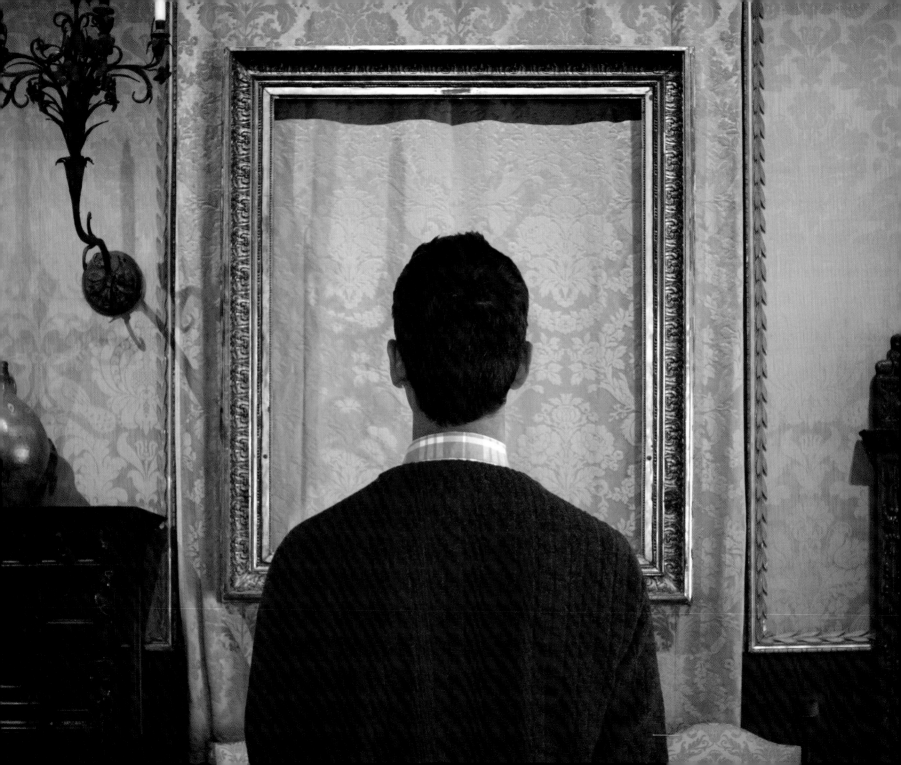

Isabella Stewart Gardner willed these works "for the education and enjoyment of the public forever," and they belong to all of us.

Foreword: A Loss for All

The art of the past lives in the present. When we view an artwork through the lens of our own emotion, knowledge, experience, and imagination, we activate its ability to speak to us today, across time and place. Great historic works achieve new meaning and new relevance when we stand in front of them and begin a personal dialogue. Whether the work is a dramatic storm at sea by Rembrandt, filled with the violent crash of waves, or an intimate concert rehearsal by Vermeer in which the masterful play of light illuminates human relationships and their setting, our encounter brings the scene to life and completes the narrative by means of our personal response. And when we visit each work again and again, the conversation evolves, as it would with a close friend.

When thieves robbed the Gardner of some of its greatest masterpieces, they deprived all of us of the chance to be part of this ongoing conversation. They relegated these objects to the past, to memory, far from the everyday encounters that keep them vital and connect them to our lives today. That is why the Gardner theft is so often described as a crime against humanity. That is why it is essential that these works be returned to the public. And that is why we at the Isabella Stewart Gardner Museum will never cease in our efforts to recover these objects and display them once again in their rightful home, where they can continue to delight, inspire, provoke, and serve, as Gardner mandated in her will, "for the education and enjoyment of the public forever."

Our intention for this book, with its images of the stolen art, is to help keep these masterworks present until we can celebrate their return—and the conversations can begin again.

— PEGGY FOGELMAN *Norma Jean Calderwood Director*, Gardner Museum

81 Minutes

In the early morning hours of March 18, 1990, two thieves gained entry to the Gardner Museum and stole 13 works of art by Rembrandt, Vermeer, Manet, Degas, and other artists. The works, including Rembrandt's *Christ in the Storm on the Sea of Galilee*, his only known seascape, and Vermeer's *The Concert*, are worth more than $500 million. The Gardner heist remains the biggest unsolved art theft in history.

At 1:24 a.m., the thieves, disguised as police officers, came to the Museum's employee entrance and requested to be let inside, stating that they were responding to a disturbance. The guard on duty broke protocol and allowed them in. Within minutes, the thieves handcuffed the two night guards, and then secured them in the Museum's basement.

The thieves proceeded to the Dutch Room on the second floor and cut Rembrandt's *Christ in the Storm on the Sea of Galilee* and *A Lady and Gentleman in Black* from their frames. They removed Vermeer's *The Concert*, one of only 36 known works by the Dutch master, and Flinck's *Landscape with an Obelisk*, from their frames, and pulled an ancient Chinese beaker, or *gu*, from a table. They took a small self-portrait etching of Rembrandt and removed his painting *Self-Portrait, Age 23* from the wall, but fortunately seem to have forgotten it, as it was discovered the next morning leaning against a chest.

It is believed that they came for the Rembrandts—and they succeeded. When they departed, they also left with nine other priceless works of art.

While one of the thieves was busy in the Dutch Room, his partner made a number of trips to the Short Gallery, where he took five Degas sketches and watercolors and a bronze Napoleonic eagle finial. Manet's *Chez Tortoni* was taken from the Blue Room, although mysteriously, the Museum's sensors did not detect any presence in that gallery.

At 2:45 a.m., 81 minutes after the thieves entered the Museum, they departed, never to be heard from again, having pulled off what is considered the biggest property theft in history. The theft was not only from the Museum but from art lovers around the world. Today, empty frames hang as place-holders until the time the art will be returned.

The Museum is offering a reward of $10 million for information leading directly to the recovery of all 13 works in good condition, and a separate $100,000 reward for the Napoleonic eagle finial. Anyone with information about the theft or location of the stolen artworks should contact the Museum at 617-278-5114 or *theft@gardnermuseum.org*. Confidentiality and anonymity are assured. —ANTHONY AMORE
Security Director and Chief Investigator, Gardner Museum

The Courtyard at night, before the theft, with the two Rembrandt paintings still visible.

The Gardner Collection

Isabella Stewart Gardner's gallery installations—the careful arrangements of decorative arts, furniture, paintings, and sculpture throughout her Museum—were, themselves, total works of art. Just as she carefully chose each piece for her collection, she clearly deliberated on the placement of each work of art in her carefully curated spaces. While a visitor to the Museum can appreciate any particular work of art on its own merits, viewing a work's placement within the purposeful groupings in the Gardner's galleries yields endless interpretive possibilities, and opens up worlds of imaginative dialogue between art from different times and places. In 13 instances, in three galleries in the Museum, these exchanges have been tragically interrupted. Gardner's original intention in placing each of her treasures just so, and our ability to be inspired by them, has been sadly cut short in the Blue Room, the Dutch Room, and the Short Gallery.

Missing from the Blue Room is Manet's image of a dapper, pensive man in *Chez Tortoni*, a work that served as a small, yet critical, counterpoint to the darker image of his aging and joyless mother, *Madame Auguste Manet*, that had hung above it. The Short Gallery drawings case is missing five Degas works on paper, with images of horse racing and musical performances that related to studies of the human figure by artists such as Bronzino and Matisse, and to costume sketches for the theatre by Léon Bakst. But it is in the Dutch Room that the absence of several masterpieces that once appeared together is most keenly felt. *The Concert* by Johannes Vermeer was previously the first work that visitors saw in the space, and its intimate domestic setting set the tone for the room. The three figures in the painting, lost in their music-making, were blissfully oblivious to us; we were allowed to silently eavesdrop. Another important conversation took place nearby, between Rembrandt's *Christ in the Storm on the Sea of Galilee*, in which the features of Rembrandt himself can be recognized in the face of one of Christ's terrified followers, and Rembrandt's *Self-Portrait, Age 23*, still in place on the gallery's opposite wall.

We look forward to the time when the connections between the works in Gardner's collection can once again be seen and appreciated, when Gardner's original installations are once again whole, and when visitors can find delight in them firsthand. —DR. CHRISTINA NIELSEN *William and Lia Poorvu Curator of the Collection and Exhibition Program*, Gardner Museum

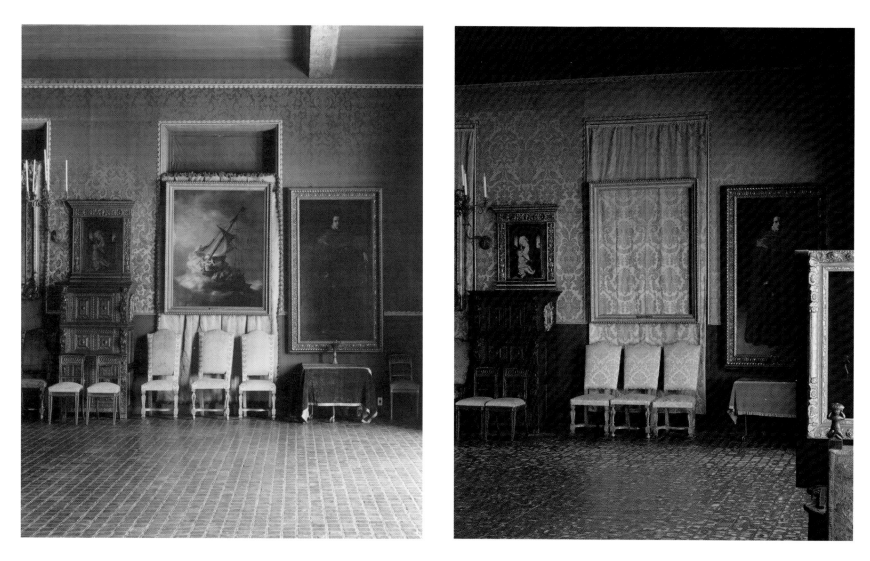

(L) The Dutch Room in 1926 showing Rembrandt's *Christ in the Storm on the Sea of Galilee*; (R) the same wall with its empty frame.

The Blue Room

The Blue Room celebrates the friends and advisors who helped Isabella Stewart Gardner create her unique collection. Located on the first floor, it once served as a ladies cloakroom for concerts and other events that Gardner held at her Museum. The paintings on display include works by artist friends John Singer Sargent, Ralph Curtis, and Dennis Miller Bunker, and show many of her interests, from a greenhouse filled with prize-winning chrysanthemums to romantic views of Venice, her favorite city. In this domestically scaled room, there are cases filled with letters, photographs, and objects related to other members of her intimate circle, as well as books that she read and collected. Like the other galleries on the first floor, the Blue Room vividly conveys a sense of what Gardner and her wide social circle looked at, thought about, and read.

The only object stolen from the first floor was taken from this room: *Chez Tortoni*, by Édouard Manet.

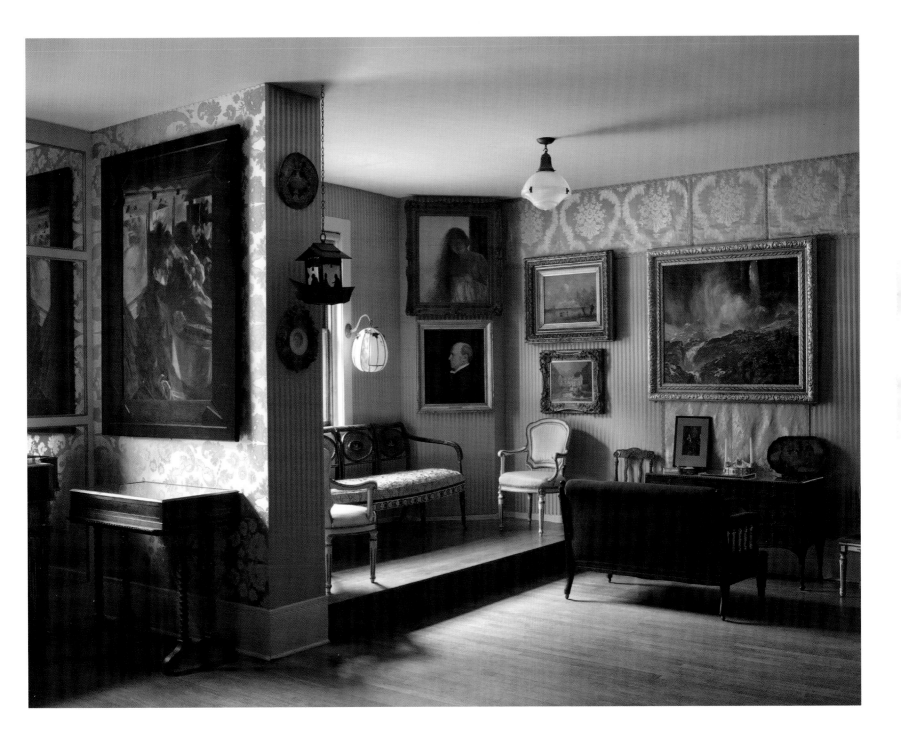

Édouard Manet (French, 1832–83)
Chez Tortoni (about 1875)

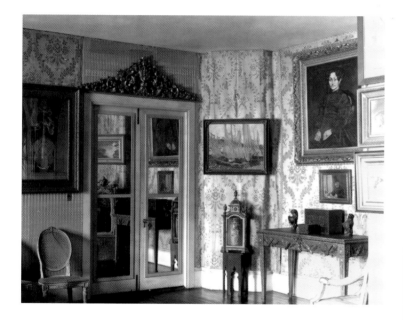

Manet's *Chez Tortoni* can be seen at the far right of this photograph, just below the portrait of the artist's mother.

Gardner installed *Chez Tortoni*, a small work by the French artist Édouard Manet, below the portrait of his mother that she had acquired more than a decade earlier. By linking this painting of a sophisticated gentleman sitting in the popular Parisian café called Chez Tortoni with the rather severe portrait of the artist's mother, Gardner set up an intriguing dialogue between the two. While Gardner never met Manet, his painterly style and love of Spanish old master painters like Velázquez (qualities shared by her friend John Singer Sargent, whose works also appear in this room) made his work a good fit for her collection.

On the night of the theft, the larger portrait had been removed for cleaning, and only the smaller Manet was on view. Purchased in 1922, two years before Gardner died, *Chez Tortoni* was the only work stolen from the first floor. Adding insult to injury, the thieves left the frame in the office of the Museum's security director at the time.

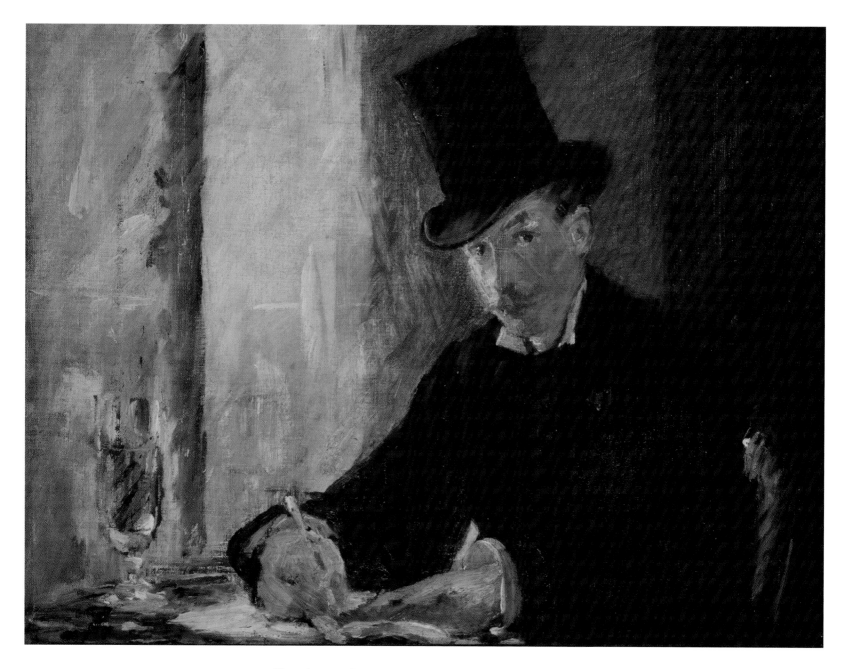

Édouard Manet, *Chez Tortoni*, about 1875, oil on canvas, 10¼ × 13⅜ in.

The Short Gallery

One of the smallest galleries in the Museum, the Short Gallery is packed with art of all kinds. Portraits of Isabella Gardner and her husband Jack are displayed along with books, furniture, bric-a-brac, and textiles. The most striking feature of the gallery is a cabinet that holds prints, drawings, and watercolors by artists from the Renaissance to Gardner's time. Works by Michelangelo, Raphael, Whistler, and the Impressionist artist Edgar Degas hang on moveable panels that visitors can adjust to catch the light for better viewing. The Short Gallery is the perfect spot to appreciate Gardner's delight in displaying works by artists of her own time alongside masterpieces of Renaissance art.

One of the many puzzling questions raised by the theft is why the thieves took five Degas drawings from the Short Gallery but left behind a Michelangelo drawing, which was close by.

Edgar Degas (French, 1834–1917)

Three Mounted Jockeys (about 1885–88), Leaving the Paddock (19th century),
Procession on a Road Near Florence (1857–60), Studies for the programme de la soirée artistique du 15 juin 1884

A total of five pieces by Degas were stolen. Purchased by Gardner in 1919 through her longtime Parisian agent Fernand Robert, the works show some of the subjects for which the artist is best known: horse racing, music, and dance. Two pieces reflect his interest in horse racing, a popular form of entertainment in the late 19th century. More interested in the human figure than most of his fellow Impressionists, Degas chose to show the jockeys and their horses in the private moments before a race began. Gardner had many artist friends, so she would have understood the importance that drawing played in working out ideas for a painting. In *Three Mounted Jockeys,* Degas experimented with different poses, while the watercolor *Leaving the Paddock (La sortie du pesage)* is a more fully developed composition, complete with architectural setting and interested bystanders.

Another work, *Procession on a Road Near Florence (Cortège sur une route aux environs de Florence)*, shows a horse-drawn carriage behind a group of figures in a typical Italian landscape.

Two other works were studies for a concert program (*programme de la soirée artistique du 15 juin 1884*). Gardner herself often created illustrated programs for the concerts she organized, so perhaps she enjoyed this point of connection with a kindred spirit. The two sketches show the artist's progression from general idea to more detailed execution; the gridded lines on the bottom left of one drawing become the masts of ships in a harbor in the other.

Edgar Degas, *Leaving the Paddock (La sortie du pesage)*, 19th century, watercolor and pencil on paper, 4 ⅛ × 6 ⁵⁄₁₆ in.

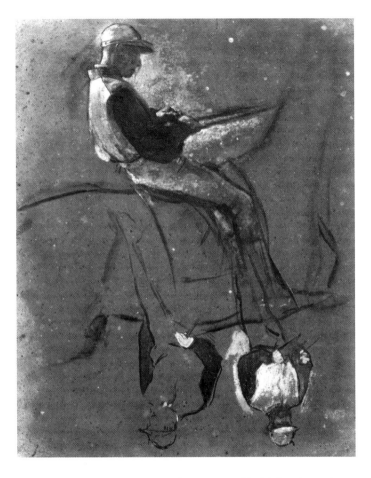

Edgar Degas, *Three Mounted Jockeys*, about 1885–88, black ink and gouache on brown paper, 12 × 9 7/16 in.

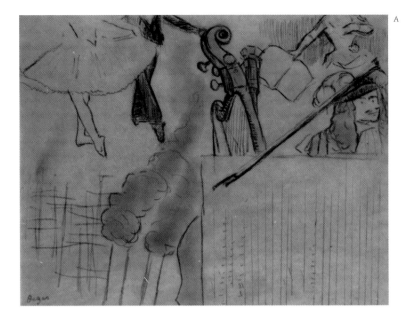

A

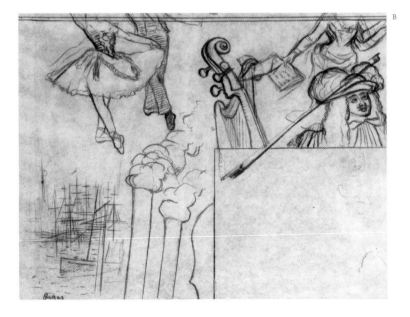

B

Edgar Degas, two works, both titled *Study for the programme de la soirée artistique du 15 Juin 1884*, black chalk on paper, (A) 9 11/16 × 12 3/8 in., (B) 10 1/2 × 14 13/16 in.

Edgar Degas, *Procession on a Road Near Florence (Cortège sur une route aux environs de Florence)*, 1857–60, pencil and sepia wash on paper, 6 ⅛ × 8 ⅛ in.

After Antoine-Denis Chaudet (French, 1763–1810)
Eagle Finial (1813–14)

The eagle finial stood atop a framed flag of Napoleon's Imperial Guard in the Short Gallery. The thieves took the finial, but left the flag.

In addition to the works on paper from the drawing cabinet, the thieves also took one unusual object from the Short Gallery: a gilded bronze eagle finial. An object of more historical than aesthetic value, this finial once decorated the top left corner of a framed flag of Napoleon's Imperial Guard.

In the late 19th century, Napoleon was admired as a strong and effective leader, creating an active market for his memorabilia. Isabella Gardner purchased both the finial and the flag in 1880 from a New York antiques dealer. During the theft, the thieves attempted to unscrew the flag from its frame but ultimately abandoned their efforts and took only the finial.

There is a separate $100,000 reward for information leading to the return of the finial. While the Gardner Museum's piece has distinct markings, eagle finials are numerous, and someone may unknowingly have the Museum's finial in their possession.

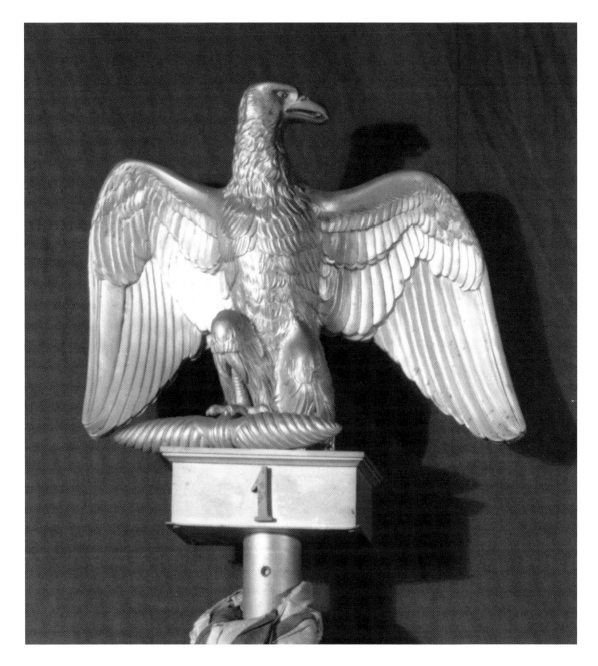

After Antoine-Denis Chaudet, *Eagle Finial: Insignia of the First Regiment of Grenadiers of Foot of Napoleon's Imperial Guard*, 1813–14. Gilded bronze, height: 10 in.

The Dutch Room

It was from the Dutch Room that the best-known works of art were taken. While Isabella Gardner's true passion was Italian Renaissance art, the first masterpieces she purchased were Dutch. She filled this gallery with artwork from the Netherlands, Germany, and England, illustrating her appreciation for the art of Northern Europe.

This gallery originally contained several important works by the Dutch artist Rembrandt, one of the most famous painters of all time. Experts believe the thieves came to the Museum primarily to steal Rembrandts. In addition to three Rembrandts, the thieves also left with a Dutch landscape once thought to be by him (now attributed to his follower, Govaert Flinck); a masterly interior scene by another Dutch painter, Johannes Vermeer; and an ancient Chinese ritual bronze vessel—making up almost half of the 13 objects taken in the theft. Today, the room contains five empty frames that once held the stolen paintings as a reminder of the gaps in Gardner's original installation.

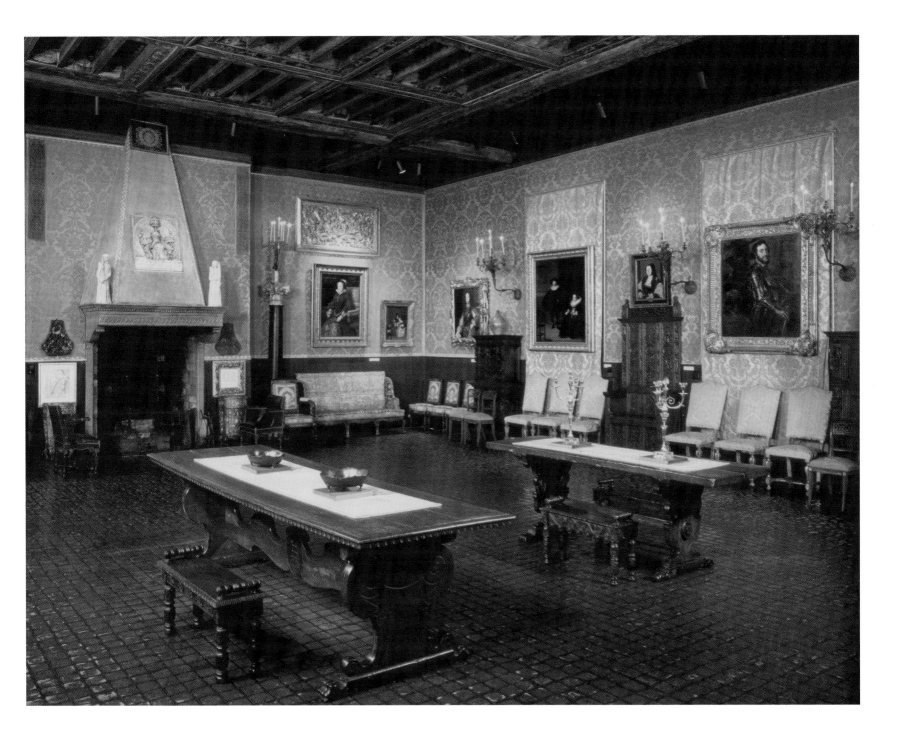

Chinese, Shang Dynasty
Beaker (*Gu*) (12th century BC)

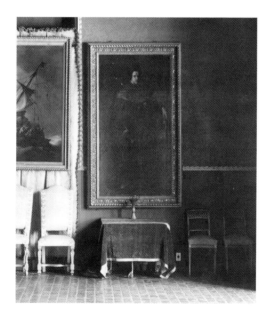

The Dutch Room in 1926, showing the Chinese vessel
on the table against the far wall.

Isabella Gardner is best known for her collection of Italian Renaissance art, but she also developed a keen appreciation for Asian art and culture, and placed Asian objects in almost every room of her Museum. The Dutch Room is no exception. She placed this *gu*, an ancient Chinese ritual vessel traditionally used for wine, on a small table in front of the portrait *A Doctor of Law* by the Spanish artist Francisco de Zurbarán. Dating from the Shang dynasty, this vessel is one of the oldest works in the collection. While it may seem surprising to see works of art from such different times and places together, Gardner used this installation technique throughout the Museum. Gardner bought the *gu* in 1922 on the advice of her friend Denman Ross, one of Boston's most prominent early collectors of Asian art.

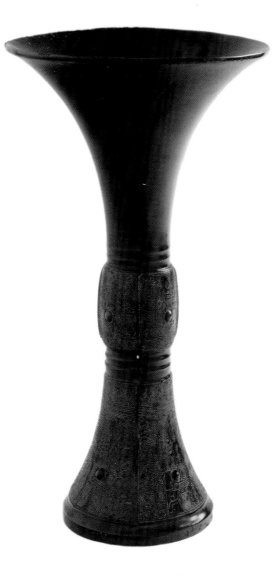

Chinese, Shang Dynasty, Beaker (Gu), 12th century BC, bronze, 10 7/16 × 6 1/8 in.

Govaert Flinck (Dutch, 1615–60)
Landscape with an Obelisk (1638)

When Isabella Stewart Gardner purchased this painting, she thought she was buying a Rembrandt. In the 1980s, scholars determined that Govaert Flinck, one of his followers, was the true artist.

Gardner collected relatively few landscape paintings. She placed *Landscape with an Obelisk* on a special tabletop stand next to a window, a prime location in a museum lit primarily by natural light. The combination of a classical obelisk in a natural setting echoes the arrangement of the Museum's courtyard garden. A chair placed in front of the table suggests a domestic environment; it also allows us to imagine Gardner sitting there, immersing herself in looking. While we don't know if Gardner allowed visitors to use the chairs this way, this type of installation, which appears throughout the Museum, continues to symbolize the ideal of long, sustained contemplation of individual works of art.

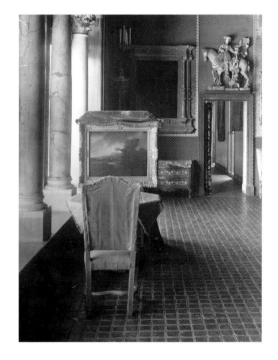

Landscape with an Obelisk sat on a custom-built stand by a window in the Dutch Room.

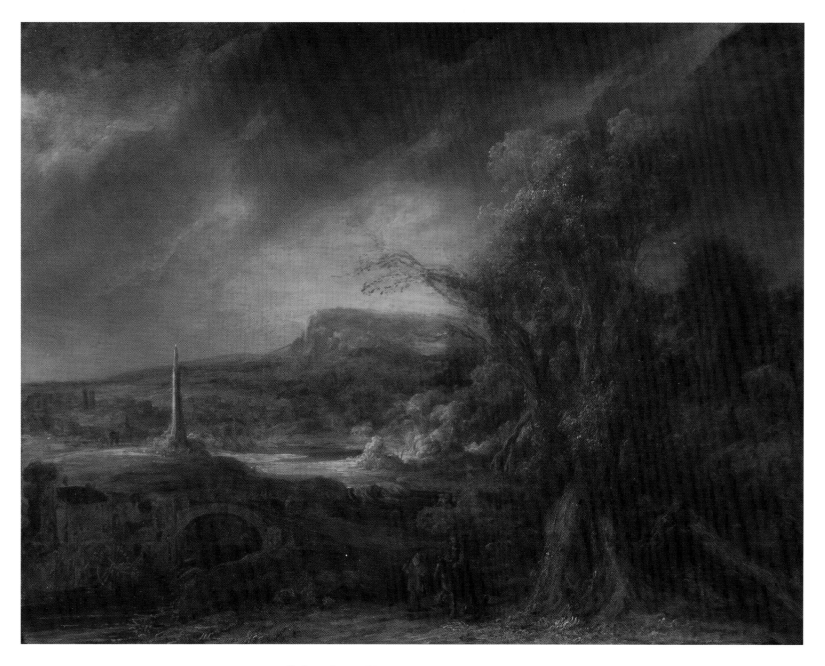

Govaert Flinck, *Landscape with an Obelisk*, 1638, oil on panel, 21 ⁷/₁₆ × 27 ¹⁵/₁₆ in.

Rembrandt van Rijn (Dutch, 1606–69)
Portrait of the Artist as a Young Man (about 1633)

The tiny etched self-portrait by Rembrandt hung
on the side of a cabinet in the Dutch Room.

One of the stolen Rembrandts is a self-portrait no larger than a postage stamp. This etching originally hung on the side of a cabinet near Rembrandt's *Self-Portrait, Age 23*. These were the first two Rembrandts Gardner bought, and their acquisition in 1896 seems to have been at the time she decided that her private collection should become a public museum. The life-sized painting was removed from the wall by the thieves, but was fortunately left behind.

Rembrandt is as famous for his prints as for his paintings, a point that Gardner underscored for visitors by installing the two self-portraits together. Despite its small size, the etched self-portrait presents a compelling sense of the personality of the young Rembrandt.

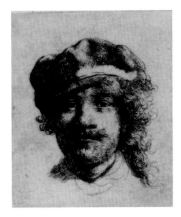

Rembrandt van Rijn, *Portrait of the Artist as a Young Man*, about 1633, etching, 1 ¾ × 1 ¹⁵⁄₁₆ in.
Shown actual size

Rembrandt van Rijn (Dutch, 1606–69)
A Lady and Gentleman in Black (1633)

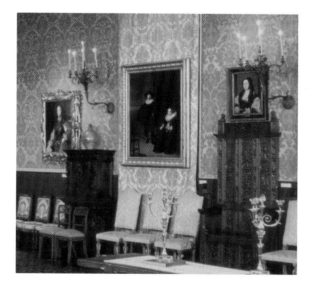

The southeast corner of the Dutch Room showing Rembrandt's
A Lady and Gentleman in Black.

In *A Lady and Gentleman in Black*, a wealthy husband and wife (their identities are unknown) are shown at home, their comfortable status indicated by their elaborate lace collars and cuffs, as well as by the map that hangs on the wall behind them. The husband stands as if he only had a few minutes to spare for the artist, while the wife is calmly seated. Such a large painting—the figures are almost life-size—would have been expensive to commission, and is another indication of the couple's wealth. Like many other artists of his time, the young Rembrandt made his living painting portraits like this one.

A Lady and Gentleman in Black hung on the same wall as Rembrandt's *Christ in the Storm on the Sea of Galilee*, allowing visitors to appreciate his skill in conveying two very different moods. Contrasting with the drama of a stormy sea, the double portrait depicts a quiet interior scene.

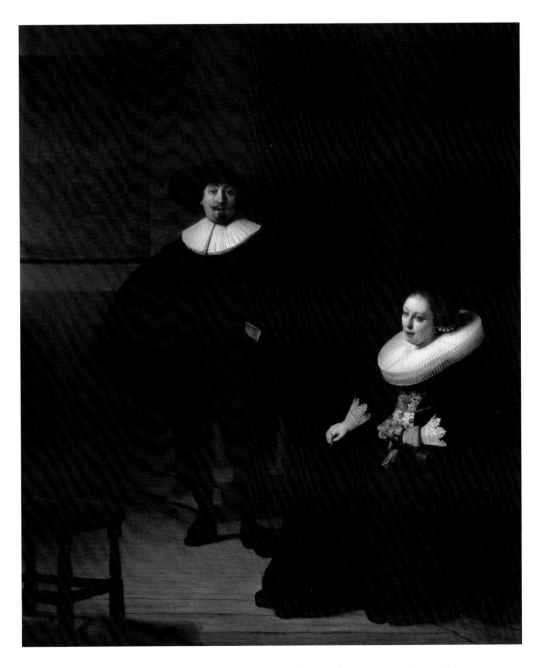

Rembrandt van Rijn, *A Lady and Gentleman in Black*, 1633, oil on canvas, 51 13/16 × 42 15/16 in.

Rembrandt van Rijn (Dutch, 1606–69)
Christ in the Storm on the Sea of Galilee (1633)

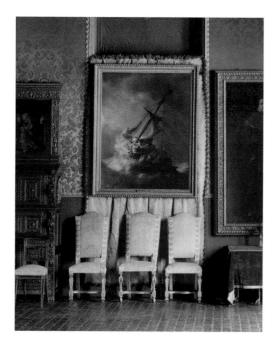

The Dutch Room in 1926, showing Rembrandt's
Christ in the Storm on the Sea of Galilee.

Christ in the Storm on the Sea of Galilee is Rembrandt's only known seascape. A narrative masterpiece, the painting depicts a biblical scene in which Jesus's ability to calm a furious storm dramatizes the power of Christian faith. While the panic-stricken disciples struggle against the storm, Christ remains seated at the stern of the ship, his calm demeanor attesting to his unwavering faith in God. The only figure on the ship that looks straight at the viewer is wearing bright green; this is a portrait of Rembrandt himself. Painted when he was just 27, *Christ in the Storm on the Sea of Galilee* shows the dramatic use of light and the play of human emotions that made Rembrandt famous.

The same skillful depiction of light and emotion can be seen in another work by Rembrandt, which hangs across the room. While no longer in the company of the three other works by the same hand, *Self-Portrait, Age 23* shows why Rembrandt deserves his reputation as one of the world's greatest artists.

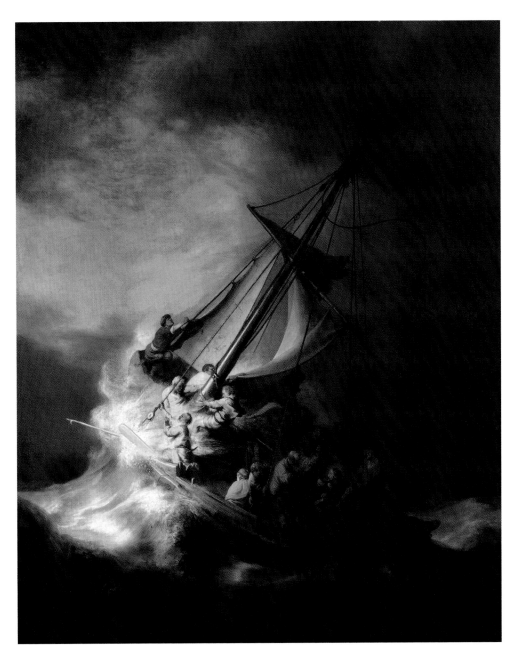

Rembrandt van Rijn, *Christ in the Storm on the Sea of Galilee*, 1633, oil on canvas, 63 × 50⅜ in.

Johannes Vermeer (Dutch, 1632–75)
The Concert (1663–66)

Vermeer's *The Concert* was Isabella Gardner's first major acquisition. Experts consider it the most valuable painting stolen from the Museum—and perhaps the most valuable stolen object in the world—because of its beauty and rarity. Vermeer is known to have completed only 36 paintings, most considered masterpieces, before he died at age 43.

Vermeer's *The Concert* was placed next to a window that provided natural light for viewing.

The painting depicts a stylish room with paintings decorating both the wall and the lid of the harpsichord. Light filters into the room from an unseen window; two women and a man (possibly a music teacher) concentrate on making music. They are in a world of their own; time feels suspended. *The Concert* brings together art and music just as Gardner did in her Museum. A colorful rug—in those days too precious an object to be placed on the floor—is a reminder of the successful shipping trade that made 17th-century Holland so prosperous.

Gardner was so excited to have the chance to purchase this painting at a Paris auction in 1892 that she personally attended the event. To bid, Gardner secretly signaled to her agent with a handkerchief. Her strategy worked. Representatives from both the Louvre in Paris and the National Gallery in London stopped bidding, believing they were raising the price by bidding against each other. Gardner walked away with the prize, and, in so doing, built an international reputation for herself as an art collector almost overnight.

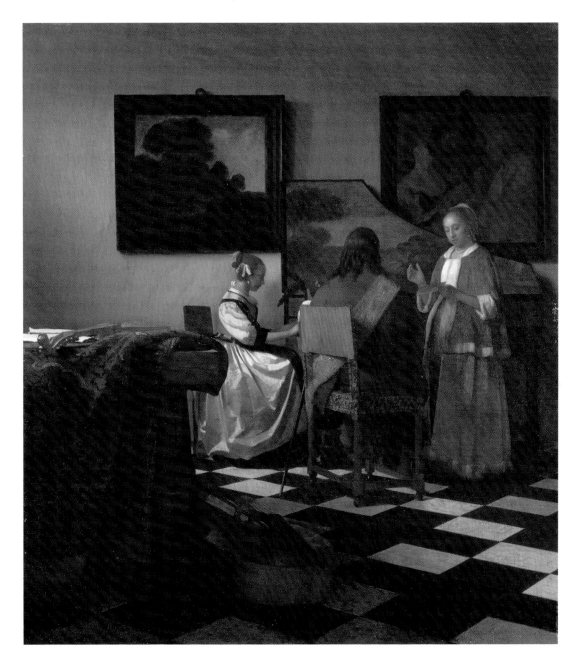

Johannes Vermeer, *The Concert*, 1663–66, oil on canvas, 28 9/16 × 25 ½ in.

Scale Diagram (1/10 scale)

Size matters! To help the public become more familiar with the stolen artworks, this diagram shows the relative sizes of the missing works, from large paintings to a tiny etching. See *Stolen Object List* on page 36 for descriptions.

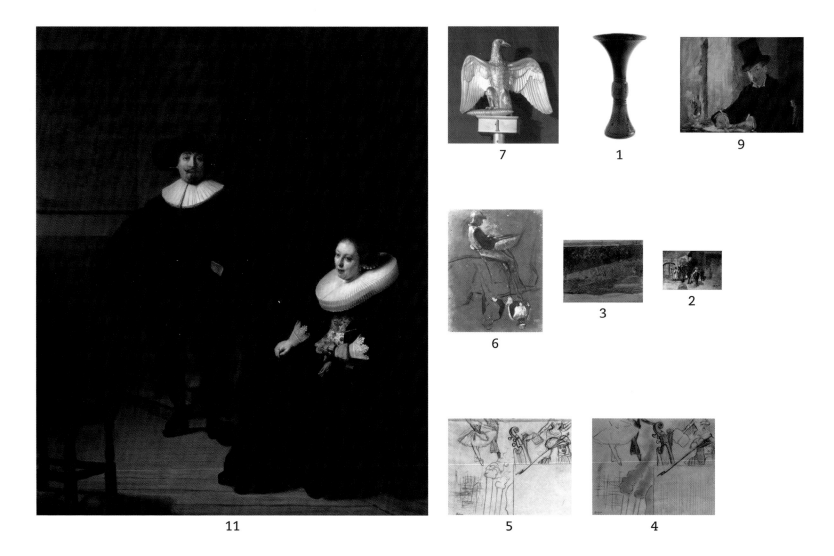

11

7

1

9

6

3

2

5

4

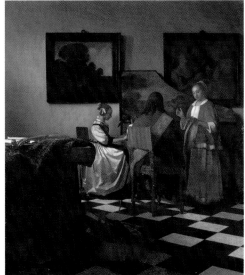

12

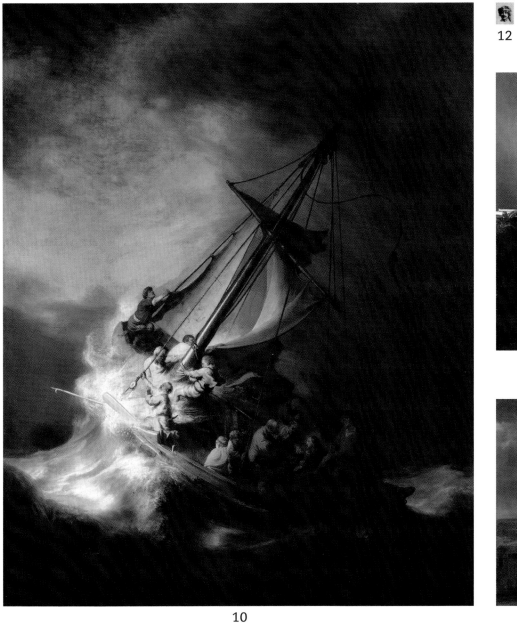

10

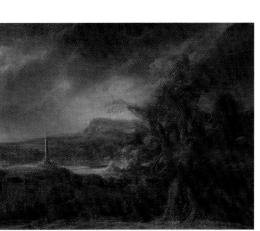

13

8

35

Stolen Object List

1. Chinese, Shang Dynasty, Beaker (*Gu*), 12th century BC, bronze, 10 7/16 × 6 1/8 in.

2. Edgar Degas, *Leaving the Paddock (La sortie du pesage)*, 19th century, watercolor and pencil on paper, 4 1/8 × 6 5/16 in.

3. Edgar Degas, *Procession on a Road Near Florence (Cortège sur une route aux environs de Florence)*, 1857–60, pencil and sepia wash on paper, 6 1/8 × 8 1/8 in.

4. Edgar Degas, *Study for the programme de la soirée artistique du 15 Juin 1884*, black chalk on paper, 9 11/16 × 12 3/8 in.

5. Edgar Degas, *Study for the programme de la soirée artistique du 15 Juin 1884*, black chalk on paper, 10 1/2 × 14 13/16 in.

6. Edgar Degas, *Three Mounted Jockeys*, about 1885–88, black ink and gouache on brown paper, 12 × 9 7/16 in.

7. After Antoine-Denis Chaudet, *Eagle Finial: Insignia of the First Regiment of Grenadiers of Foot of Napoleon's Imperial Guard*, 1813–14. Gilded bronze, height: 10 in.

8. Govaert Flinck, *Landscape with an Obelisk*, 1638, oil on panel, 21 7/16 × 27 15/16 in.

9. Édouard Manet, *Chez Tortoni*, about 1875, oil on canvas, 10 1/4 × 13 3/8 in.

10. Rembrandt van Rijn, *Christ in the Storm on the Sea of Galilee*, 1633, oil on canvas, 63 × 50 3/8 in.

11. Rembrandt van Rijn, *A Lady and Gentleman in Black*, 1633, oil on canvas, 51 13/16 × 42 15/16 in.

12. Rembrandt van Rijn, *Portrait of the Artist as a Young Man*, about 1633, etching, 1 3/4 × 1 15/16 in.

13. Johannes Vermeer, *The Concert*, 1663–66, oil on canvas, 28 9/16 × 25 1/2 in.

978-1-944038-52-6

10 9 8 7 6 5 4 3 2

Published by Benna Books
an imprint of Applewood Books, Inc.
Carlisle, Massachusetts 01741
www.awb.com

Printed in China

Gardner Museum Contributors

Peggy Fogelman, *Norma Jean Calderwood Director*
Anthony Amore, *Security Director and Chief Investigator*
Dr. Christina Nielsen, *William and Lia Poorvu Curator of the Collection and Exhibition Program*
Peggy Burchenal, *Esther Stiles Eastman Curator of Education*

Project Editor: Kathy Sharpless
Producer: Victor Oliveira
Design Editor: Faith Diver
Copy Editor: Susan Feldman
Collections Editor: Elizabeth Reluga

Photographic Credits

Numbers indicate on which page the images appear.

© 2017 Artists Rights Society (ARS), New York / ADAGP, Paris: 2

Sean Dungan: 9

David Mathews: 7 (R), 26

Thomas E. Marr and Son: 7 (L), 10, 13, 18, 22, 24, 30

All other images courtesy of the Isabella Stewart Gardner Museum